KEEP
WHAT YOU
LOVE

A VISUAL DECLUTTERING GUIDE

A **flow** BOOK

KEEP
WHAT YOU
LOVE

A VISUAL DECLUTTERING GUIDE

Irene Smit & Astrid van der Hulst
ILLUSTRATED BY LOTTE DIRKS

WORKMAN PUBLISHING • NEW YORK

Cover and title page background texture: Lisa Kundzeleviciene/
Shutterstock.com

Library of Congress Cataloging-in-Publication Data is available.

ISBN 978-1-5235-0943-0

Design by Rae Ann Spitzenberger
Text compiled by Caroline Buijs
Translations by Julia Gorodecky

Workman books are available at special discounts when purchased in
bulk for premiums and sales promotions as well as for fund-raising or
educational use. Special editions or book excerpts can also be created to
specification. For details, contact the Special Sales Director at the address
below or send an email to specialmarkets@workman.com.

Workman Publishing Co., Inc.
225 Varick Street
New York, NY 10014-4381
workman.com
flowmagazine.com

WORKMAN is a registered trademark of Workman Publishing Co., Inc.
FLOW is a registered trademark of Sanoma Media Netherlands B.V.
Printed in China
First printing February 2020

10 9 8 7 6 5 4 3 2 1

Do You Really Need It?

AS AVID LOVERS OF STUFF, WE *NEVER* THOUGHT that we would one day be in the position to write a book about decluttering. But we each reached a point in our lives where we felt a bit trapped by our stuff. Irene, who loves to visit vintage shops and flea markets, decided to reorganize her home and let go of all the lovely but not-so-necessary decorative tins, charmingly mismatched cups, and old books. Astrid began her own yearlong decluttering project, partly because she was longing for a simpler life, partly because she wanted to reduce her environmental footprint, and partly because she became more keen on the idea of spending money on adventures and making memories rather than on stuff. So she looked at the things she had amassed in her life, and began asking the question, *Do I really need this?—Do I really need a knife for every type of fruit? Do I really need this bread maker? Do I really need that drawerful of wool socks?* Sometimes the answer was yes, and many times it was a clear no. Yes, she needed her son's childhood blanket, because it reminded

her of the nights she slept next to his crib when he was a bit restless. But the umbrella could go—after all, what's wrong with wearing a raincoat and feeling a bit of rain on your face? On the other hand, Irene has had her camping gear in storage for years, but buying a camper is a dream that she is not ready to let go of yet, so those boxes remained untouched. We realized that taking a moment to acknowledge your relationship with an item before deciding whether it should stay or go is also thinking about who you are or would like to become.

We will continue to identify as stuff-lovers, but since our decluttering projects, we are more aware of what we really need and what we can let go. Decluttering is not a rigid command to become a minimalist; rather, it is a soft and slow way to reset and make choices about your life. As you move through the pages of this book, think about what each item represents in your own life, and ask yourself, every time you turn the page: *Do I really need it?* And then, once you've reached the end, on page 235, ask yourself whether you still need this book—or is it time to share it with a friend?

XO,

Astrid & Irene

All that stuff
still sitting in boxes
after your last move

☐ Yes ☐ No

Those
"What's this for?"
chargers

☐ Yes ☐ No

Lots of pens

☐ Yes ☐ No

Novelty ice cube tray

☐ Yes ☐ No

Manual typewriter

☐ Yes ☐ No

Once-a-year equipment

☐ Yes ☐ No

BORROW, DON'T BUY

It's so easy to accumulate stuff that we sometimes forget we have an alternative: Borrow it! From bread makers to power drills to ski equipment to formal wear, we allow a vast amount of *stuff* to take up space in our lives just to be used once a year and then returned to storage. When you're planning your next big purchase, instead of heading to the store, why don't you call up your neighbor and ask to borrow it? (Or rent it—many hardware stores, for instance, have a rental program for power tools.) This small change will give you a chance to connect with someone in your community. Plus, at the end of the day, you may even be surprised by how good it feels to return the item, instead of clearing space to store it.

Plant that can
no longer be saved

☐ Yes ☐ No

Incomplete board games

☐ Yes ☐ No

Dressy clothes

☐ Yes ☐ No

Smelly sports shoes

☐ Yes ☐ No

Umbrella

☐ Yes ☐ No

RECONSIDER THIS

Sometimes it's not about whether something is broken or shabby, it's about whether the item is actually necessary in your life. A fully functional umbrella seems like a no-brainer. But if you have a raincoat and boots, do you really need an umbrella, too? Maybe it's not so bad to get a sprinkling of rain on your face from time to time. Rather than mope about getting caught in a downpour, enjoy the refreshing shower!

Oven mitts

☐ Yes ☐ No

Dried flowers

☐ Yes ☐ No

"Hanging on
is fear;
letting go
is hope."

—DAPHNE ROSE
KINGMA

Dollhouse

☐ Yes ☐ No

Roller skates

☐ Yes ☐ No

Deer antlers

☐ Yes ☐ No

Evening dress

☐ Yes ☐ No

CHOOSE SECONDHAND INSTEAD OF NEW

Shopping secondhand is not only easier on your wallet, but also benefits the environment by reducing water consumption and CO_2 emissions. And you may be surprised by what you find hidden in the corner of your local thrift shop—a one-of-a-kind sweater, a new favorite book, or perhaps the perfect lamp to complement your living room (but only if you need it!).

Vases

☐ Yes ☐ No

Escargot tongs
and fork

☐ Yes ☐ No

Well-worn bathrobe

☐ Yes ☐ No

Wallpaper scraps

☐ Yes ☐ No

HOW TO LET GO

Saying good-bye can be a difficult part of decluttering—especially when it comes to items of sentimental value. To make the process easier, Marie Kondo suggests acknowledging the memory of the object and pleasure it brought you, then saying thank you before getting rid of it.

Old cuddly toys

☐ Yes ☐ No

Lots of condiments

☐ Yes ☐ No

Old phones

☐ Yes ☐ No

A heavy
Norwegian sweater

☐ Yes ☐ No

A bread maker

☐ Yes ☐ No

Children's artwork

☐ Yes ☐ No

KID CLUTTER

Children are endlessly creative and incredibly prolific! Here are some ideas for taming the loads of artwork collecting on the fridge and piling up on the table:

- Select a few of your favorite art projects to frame and hang. Photograph or scan the rest and save them in a special folder on your phone, computer, or flash drive; recycle or reuse the originals.

- Not ready to go digital? There are companies that will turn your photos and scans into a printed book, or you may opt to scrapbook special projects or photos as a fun and screen-free way to memorialize your child's hard work.

- Send extra art to grandparents (or repurpose it into greeting or thank-you cards).

- Use paintings and drawings as wrapping paper.

So many
sofa cushions

☐ Yes ☐ No

Textbooks
from your
school days

☐ Yes ☐ No

Blank notebooks

☐ Yes ☐ No

Clothes with tags
still attached

☐ Yes ☐ No

TIP 1

Make it a habit to take
ten minutes to tidy up before
you go to bed in the evening.
Put your dirty cups in the
dishwasher, hang or fold any
clothing strewn about, place
your shoes near the door. Your
morning will be smoother and
you will leave the house
with a clear head.

A different
pair of sneakers
for each day

☐ Yes ☐ No

Plastic containers

☐ Yes ☐ No

Holiday cards

☐ Yes ☐ No

Cross-body bags

☐ Yes ☐ No

Old ballet shoes

☐ Yes ☐ No

Statuettes

☐ Yes ☐ No

YOUR TRASH
IS TREASURE

It sounds like a cliché, but it's true: One person's trash is another's treasure. If you don't use something, pass it on or take it to the thrift store—this lets someone else fall in love with it and give it a new beginning.

Speakers

☐ Yes ☐ No

Garden torches

☐ Yes ☐ No

WHEN IT'S TIME TO LET GO

If the phrase "But what if I need it someday . . .?" feels overly familiar, decluttering can pose an extra challenge. It's hard to part with items that are fully functional, even if they're not exactly useful to you. Try applying the following test: Have I used this item in the past year? If not, you may want to say good-bye.

A blender

☐ Yes ☐ No

An empty shoebox

☐ Yes ☐ No

Party shoes

☐ Yes ☐ No

Nuts and screws

☐ Yes ☐ No

"Anything
I can not
transform
into something
marvelous,
I let go."

—ANAÏS NIN

Enough bed linens
to stock a hotel

☐ Yes ☐ No

Binders

☐ Yes ☐ No

Broken watches

☐ Yes ☐ No

So many teaspoons

☐ Yes ☐ No

SIMPLE TRICKS
FOR ORGANIZING

- Use small, transparent containers for storage and label them with what's inside.

- Store everything by type, even small things like safety pins, birthday candles, unused batteries, or bobby pins.

- Sort, label, and neatly wrap any cords or chargers—recycle or dispose of anything that remains a mystery.

Lighters

☐ Yes ☐ No

Pineapple corer

☐ Yes ☐ No

A lamp in the
shape of a goose

☐ Yes ☐ No

Record player

☐ Yes ☐ No

Unopened
perfume samples

☐ Yes ☐ No

TIP 2

Try to get in the habit of leaving a room with your hands full. If you walk from the living room to the kitchen, check whether you can take dirty dishes or trash with you. If you walk from your bedroom to the bathroom, take any clothes that can be put in the laundry basket. You will have tidied up before you know it!

Pajamas

☐ Yes ☐ No

Rolled-up posters

☐ Yes ☐ No

Hammock chair

☐ Yes ☐ No

3-D glasses
from the movies

☐ Yes ☐ No

Heels you can't walk in

☐ Yes ☐ No

Books you've
already read

☐ Yes ☐ No

WHEN CLEANING OUT A BOOKSHELF, CONSIDER EXTENDING A BOOK'S LIFE

- If you live in an urban area, you can place gently used books on the sidewalk for passersby to peruse.

- Build your own Little Free Library (littlefreelibrary.org) and keep it stocked with your old book club picks.

- Speaking of libraries . . . some libraries, schools, and charitable organizations are happy to receive donations of gently used books.

- Give a new life to an old or damaged book by using the pages as a canvas for your next drawing or painting.

- Repurpose beautiful pages from large books that are no longer readable as wrapping paper or frame them as wall art.

Undershirts

☐ Yes ☐ No

Cassette tapes

☐ Yes ☐ No

Souvenir snow globe

☐ Yes ☐ No

Certificates
and diplomas

☐ Yes ☐ No

Theater programs

☐ Yes ☐ No

Backpack

☐ Yes ☐ No

FIND THE JOY

We're tempted to ask the more practical ques-
tions: *Can this be repaired? Might I use this in
the future?* or *Is this valuable?* Instead, Marie
Kondo suggests asking, "Does this spark joy?"—a
simple question that will help you truly consider
your relationship with each item before making
a decision to keep it or discard it.

Stamp collection

☐ Yes ☐ No

Flip-flops

☐ Yes ☐ No

Taxidermy

☐ Yes ☐ No

Comic books

☐ Yes ☐ No

Ice-cream scoops

☐ Yes ☐ No

Knitted throws

☐ Yes ☐ No

TIP 3

Create a daily ritual of
making your bed. It takes
very little time, your bedroom
immediately looks tidier, and
if you incorporate it into
your routine, the task
will become second
nature.

A beautiful Persian rug
that doesn't quite match
the decor

☐ Yes ☐ No

All of those
drawing and painting
implements

☐ Yes ☐ No

Whistling teakettle

☐ Yes ☐ No

Rocking horse

☐ Yes ☐ No

A very eccentric apron

☐ Yes　　☐ No

THE GIFT OF
GOOD COMPANY

As you embark on your decluttering journey, consider how you can avoid adding to your loved ones' clutter. Why not give gifts of experience (date nights, concerts, a nice home-cooked meal, travel adventures) rather than material items? Of course, the reverse is also true: When it comes to your own birthday gifts, consider asking for an experience instead of more "stuff."

Fishing gear

☐ Yes ☐ No

Hamster cage

☐ Yes ☐ No

Beach chair

☐ Yes ☐ No

Completed jigsaw puzzles

☐ Yes ☐ No

Egg slicer

☐ Yes ☐ No

"The ability
to simplify means
to eliminate
the unnecessary
so that the necessary
may speak."

—HANS HOFMANN

Piano practice book

☐ Yes ☐ No

Goat wool socks

☐ Yes ☐ No

Winter tires

☐ Yes ☐ No

Holiday dinnerware

☐ Yes ☐ No

Cotton tote bags

☐ Yes ☐ No

Bookends

☐ Yes ☐ No

CLOSET CLEANUP

Do you ever feel that though your closets are bursting at the seams, you have nothing to wear? Try these tips for clothing organization:

- Roll clothes that are in drawers to more easily access what you have.

- Use only one type of clothes hanger; your clothes will fit in the closet more efficiently, and they will be easier to see when hanging in a tidy row.

- Use old shoe boxes as drawer organizers to create compartments for socks and other small items.

- Try placing all of your hangers backward on the closet bar. As you wear an item, replace the hanger in the right direction. After a year, note each piece of clothing that is still hanging backward, and considering letting it go.

Cradle

☐ Yes ☐ No

Spaghetti pot

☐ Yes ☐ No

Collected stones

☐ Yes ☐ No

Stroller

☐ Yes ☐ No

Newspapers

☐ Yes ☐ No

A NEW LIFE
FOR OLD CLOTHES

Do you have a threadbare piece of clothing that holds emotional value for you? Cut a square out of the fabric and save it in a scrapbook or memory box, turn it into a doll's blanket, or combine a number of items to make a quilt or wall hanging. Bring the remainder to a textile recycling center.

Tools for a hobby that
didn't quite take

☐ Yes ☐ No

Champagne glasses

☐ Yes ☐ No

Loungewear

☐ Yes ☐ No

Postcards

☐ Yes ☐ No

Empty picture frames

☐ Yes ☐ No

Grandma's lamp

☐ Yes ☐ No

Feather duster

☐ Yes ☐ No

Soup bowls

☐ Yes ☐ No

TIP 4

Tidying up does not mean
moving things from one pile
to the next. Tidying up means:
finishing the job at hand and
putting everything in its
place (the shelf or cupboard
where it belongs—or the
garbage or giveaway
bag).

Old cameras

☐ Yes ☐ No

Phone cases

☐ Yes ☐ No

Rocking chair

☐ Yes ☐ No

Clutch

☐ Yes ☐ No

A SHIFT IN PERSPECTIVE

Try this on for size: *You do not have to buy anything; you already have everything.* Wearing your partner's shirt might be nicer than buying a new one. That old chair from your college days may make an unexpectedly nice reading chair if you arrange a throw blanket over it. Try not to get taken in by planned obsolescence—use a device until it is completely worn out, or have it repaired and keep using it. How much more satisfying does a pencil become if it is used to its last inches? Your oven mitt may be a little dull, but it still does its job. And your old scissors may not look as cool as those trendy new ones, but they still cut wonderfully.

Sheepskins

☐ Yes ☐ No

Figurines

☐ Yes ☐ No

Flower seed envelopes

☐ Yes ☐ No

"Your home
is not
a museum."

—ANDREW MELLON

Cat or dog toys

☐ Yes ☐ No

Knitting needles
and crochet hooks

☐ Yes ☐ No

Thermos

☐ Yes ☐ No

Expired pantry items

☐ Yes ☐ No

WASTE NOT, WANT NOT

Think about the last time you tossed a banana because it was too brown, forgot about the now-slimy cilantro that you meant to add to your tacos, or passed over last night's leftovers. About one-third of all food produced globally goes to waste. Prevent fridge clutter *and* save your food with these tips:

- Plan out meals and buy only what you'll need for those meals while grocery shopping.

- Use smaller plates to prevent overserving your friends and family.

- Don't toss that overripe produce—it may be just what you need for cooking. Think: banana nut bread, casseroles, and soups.

- When dining out, try to order only what you can eat.

And, of course, remember to compost any appropriate foods that are beyond rescue.

Display cases

☐ Yes ☐ No

Sleeping or
yoga mats

☐ Yes ☐ No

Guitar or ukulele

☐ Yes ☐ No

Wicker baskets

☐ Yes ☐ No

THE BIG PICTURE

Experts differ on what technique works best for tackling clutter in your home—we say, do what works for you! Here are a few tips to try:

- As you declutter, clear out and refill one complete space at a time: a cupboard, a drawer, a shelf. Choosing what to keep is easier if you let everything pass through your hands.

- According to Marie Kondo, it's easiest to organize by category. For example, collect and sort all your books together, even if there are bookshelves in different rooms.

- Try focusing your efforts for just ten minutes at a time instead of an hour. You may find that you get more done when you have a smaller goal in mind.

Letterpress tray

☐ Yes ☐ No

Leg warmers

☐ Yes ☐ No

Fruit bowl

☐ Yes ☐ No

Empty moving boxes

☐ Yes ☐ No

Fine silverware

☐ Yes ☐ No

Table grill

☐ Yes ☐ No

CLEAR THE KITCHEN

Kitchens can be packed to the gills with all sorts of gadgets and tools. Some of them may make your life easier; others may be gathering dust. Here's a list of some specialty items that, if you have, you may want to consider letting go of (along with your five extra spatulas):

- Apple corer
- Asparagus peeler
- Banana slicer
- Butter cutter
- Egg separator
- Hot dog toaster
- Pizza shears
- Quesadilla press
- Strawberry slicer

Half-empty
shampoo bottles

☐ Yes ☐ No

Old drama scripts

☐ Yes ☐ No

Ceramic vase
you made yourself

☐ Yes ☐ No

Power drill

☐ Yes ☐ No

DECIDE, AND THEN DO IT!

Once you make the decision to remove an item from your home, do so immediately (like pulling off a bandage). Lingering too long will allow doubt to creep in, and you'll quickly find yourself coming up with reasons to keep items that you've already placed in your get-rid-of pile.

Decorative starfish

☐ Yes ☐ No

Crème brûlée ramekins

☐ Yes ☐ No

Random foreign coins

☐ Yes ☐ No

Sleeping bag

☐ Yes ☐ No

Old pattern books

☐ Yes ☐ No

Tablecloths

☐ Yes ☐ No

TIP 5

If you have done 80 percent
of the cleaning that needs to be
done, you do not have to focus on
the other 20 percent. It's not
necessary to muck out your entire
bookcase or dust the top of
your closet every time,
only when you're doing
a big cleanup.

Plastic animals

☐ Yes ☐ No

Candle plate

☐ Yes ☐ No

Stacks of letters

☐ Yes ☐ No

Weights

☐ Yes ☐ No

That one spice
that you buy
every time

☐ Yes ☐ No

"People
cannot change
their habits
without first
changing their way
of thinking."

—MARIE KONDO

Child's place setting

☐ Yes ☐ No

Side table

☐ Yes ☐ No

Glass cloche for
indoor plant

☐ Yes ☐ No

Windup music box

☐ Yes ☐ No

DON'T LET YOUR
THINGS OWN YOU

Things take up a lot of time: shopping, swapping, storing, dusting, repairing, moving, etc. Here are some fun ways to spend time instead:

- Ride a bike.

- Take a walk.

- Visit a museum or gallery.

- Enjoy a meal out.

- Watch a documentary.

- Get tickets to the theater.

- Go out dancing.

- Attend a class to learn a new skill.

"Honey,
I love you!"
notes

☐ Yes ☐ No

Decorative teapot

☐ Yes ☐ No

Old magazines

☐ Yes ☐ No

Clothing that doesn't
quite fit right

☐ Yes ☐ No

Empty jars

☐ Yes ☐ No

Jewelry you
no longer wear

☐ Yes ☐ No

REDUCE, REUSE, REPURPOSE!

If your jewelry is in good condition, but you no longer wear it, give it to a friend or sell it online. If you're still attached, it's time to get creative. Here are a few ideas for how to repurpose matchless earrings:

- Turn a dangly earring into a pendant necklace or a charm on a keychain.

- Wear a lone stud earring as a lapel pin.

- Throw caution to the wind and wear mismatched earrings as a set!

Lemon-shaped
tea infuser

☐ Yes ☐ No

Pennants

☐ Yes ☐ No

Paper invitations

☐ Yes ☐ No

A fashion doll

☐ Yes ☐ No

JUST SAY NO

They're made to entice you, but try not to be tempted by freebies. What initially feels like a good opportunity may quickly turn into a burden. So, no gimmicky collectibles from the supermarket. No trial shampoos from the drugstore. No giveaways from your neighbor. No brochures, no flyers, no key chains, no lanyards.

Cup(s) with a
novelty straw

☐ Yes ☐ No

Old travel guides

☐ Yes ☐ No

Herb scissors

☐ Yes ☐ No

Electric pressure washer

☐ Yes ☐ No

Everything you've ever
won at the fair

☐ Yes ☐ No

Sales receipts

☐ Yes ☐ No

HOW TO BUY LESS

The truth is, at a certain point in our lives, we likely have most of what we need, and most of us can afford to be more selective when we introduce a new item into our home or closet. To cut down on intake, make a list of questions that align with your particular values. Before making a purchase, ask yourself: *Was it ethically made? How many of this item do I already own? Is this durable and well made? Will this item make a lasting difference for me/my wardrobe/my life? What can I get rid of to make room for this item (something new in = something old out)?*

DVDs

☐ Yes ☐ No

Collected shells

☐ Yes ☐ No

Camping tent

☐ Yes ☐ No

Empty plant pots

☐ Yes　　☐ No

TIP 6

Know what you have
in your home and use an
organization system that
makes sense to you. Items are
more useful when you know
where they are and you can
easily find them.

Bakeware

☐ Yes ☐ No

Paper maps
or atlases

☐ Yes ☐ No

Scarves

☐ Yes ☐ No

Print dictionary

☐ Yes ☐ No

Earrings
with no backs

☐ Yes ☐ No

Watering can

☐ Yes ☐ No

START SMALL

Spend a moment seriously and critically looking at one small space in your home. The "junk" drawer, the bathroom cabinet, or a sock drawer are often good places to start because they don't tend to hold many sentimental possessions. Then ask yourself: *What can go?*

Scraps of yarn

☐ Yes ☐ No

Outgrown toys

☐ Yes ☐ No

VCR

☐ Yes ☐ No

Hair clips

☐ Yes ☐ No

"To let go is to release the images and emotions, the grudges and fears, the clingings and disappointments of the past that bind our spirit."

—JACK KORNFIELD

Lago di Como

Vacation souvenirs

☐ Yes ☐ No

Everything cracked
or chipped

☐ Yes ☐ No

Unused cookbooks

☐ Yes ☐ No

Bicycle basket

☐ Yes ☐ No

Deep fryer

☐ Yes ☐ No

A half-finished
craft project

☐ Yes ☐ No

WHEN TO LET GO

How long does a half-knitted scarf need to languish in the basket next to the couch before you call it quits? How do you know when the mending pile has gotten so high as to render obsolete any savings you might achieve by doing it yourself versus taking it to a tailor? Is length of time even an appropriate measure? Perhaps the better question to ask yourself is whether the project still gives you a creative spark. (Or, conversely, is it the cause of a creative rut?) If it doesn't excite you, it's time to let it go.

Paper lanterns

☐ Yes ☐ No

Rattan chair

☐ Yes ☐ No

Multiple swimsuits

☐ Yes ☐ No

Paper or fabric
garlands

☐ Yes ☐ No

GO PAPERLESS

Piles of paper accumulate on every surface every day (new bills and junk mail, new notes home from school, work documents, school binders, magazines, and so on). Here are some tips for cutting down on the paper clutter:

- Find out which formal documents you can scan and save digitally.

- Sign up for paperless billing.

- Unsubscribe from catalog mailing lists (sometimes this is easier said than done).

- Keep your papers in one place so you can sort through them regularly and toss anything that doesn't need attention into the recycling or shredding bin.

Stacks of papers

☐ Yes ☐ No

Superhero doll

☐ Yes ☐ No

Yellowed photo album

☐ Yes ☐ No

Novelty
pencil sharpeners

☐ Yes ☐ No

A magnifying glass

☐ Yes ☐ No

Bottles with
beautiful labels

☐ Yes ☐ No

TIP 7

Discard or recycle as
much packaging as possible. If
you can't put a discarded carton,
bottle, box, or other material to
immediate reuse (for example, turning a
beautiful empty bottle or can into a vase
because you don't already have a vase),
move it to its next viable resting
place: the recycling bin. Don't keep
it around just because you might
have a use for it sometime
in the abstract
future.

Coasters

☐ Yes ☐ No

Souvenir gift from your aunt
who's always traveling

☐ Yes ☐ No

THROUGH THE EYES
OF A CHILD

Decluttering is all about consistently resetting your frame of mind to recognize what actually suits your life *now* (not two days or two weeks or two years from now—and certainly not two weeks *ago*). Children are naturally adept at seeing the world this way; they are less driven by the emotional value of an object and aren't often hindered by the weighted notion of "who knows, it may come in handy someday." For them, it's the now that matters. There may be that rare occasion when you're able to use something that's been in the garage for years, but will that one moment outshine the value of living with less clutter in the meantime? More often than not, we forget that we even have an item we've been saving for such an occasion, or it's broken or missing by the time we need to use it.

The "you never
know . . ." stuff

☐ Yes ☐ No

A parrot-shaped
candlestick

☐ Yes ☐ No